GW00514834

Oxford 2023

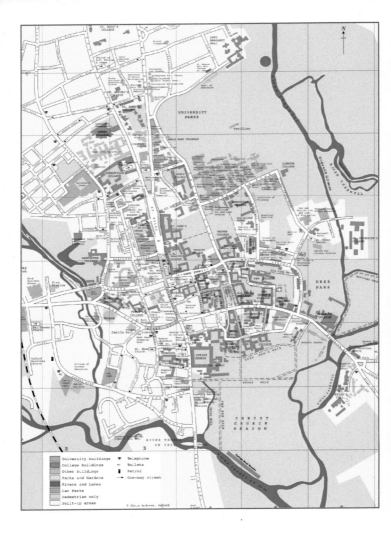

Personal

Name

Address

Tel

Mobile

Email

Doctor

Doctor Tel

Blood Group

Dentist

Dentist Tel

In Emergency Contact

Name

Telephone

OXFORD INFORMATION

Oxford University Term dates - 2022-2024

Michaelmas 2022
Sunday 9th October Saturday 3rd December

Hilary 2023
Sunday 15th January Saturday 11th March

Trinity 2023
Sunday 23rd April Saturday 17th June

Michaelmas 2023 *
Sunday 8th October Saturday 2nd December

Hilary 2024 *
Sunday 14th January Saturday 9th March

Other dates in 2023 *:
Encaenia 21st June
Torpids 22nd -25th February
Eights Week 24th-27th May
St Giles' Fair 4th-5th September

* provisional dates

NOTE : Sunrise/sunset (+/- 5 minutes), Equinox & Solstice times given
in the diary are as at Oxford, UK

OXFORD INFORMATION

ENTERTAINMENT

New Theatre, George Street — Box Office — 0870 6063501
Pegasus Theatre, Magdalen Road — 01865 722851
Oxford Playhouse, Beaumont Street — 08165 305305
Sheldonian Theatre, The Broad — 01865 277299
Music at Oxford -242865 — Box Office — 0870 7500659
Old Fire Station, George Street — 01865 279170
Odeon Cinema, George St & Magdalen St — 0871 224 4407
Phoenix Picture House, Walton Street — 01865 554909
Oxford University Sports Complex — 01865 240476
Oxford Ice Rink — 01865 467000
Temple Cowley Pools, Cowley — 01865 467100
Bowlplex, Ozone Leisure Park — 01865 714100

LIBRARIES

Ashmolean Library, Beaumont Street — 01865 278092
Bodleian Library, Broad Street — 01865 277000
Central Library, Westgate — 01865 815509

MUSEUMS

Ashmolean Museum, Beaumont Street — 01865 278000
Museum of Modern Art, Pembroke Street — 01865 722733
Museum of Oxford, St Aldates — 01865 252761
Pitt Rivers Museum, Parks Road — 01865 270927
University Museum, Parks Road — 01865 272950

TRAVEL

Oxford Bus Company — 01865 785400
Stagecoach — 01865 772250
Railway Station — 0845 7484950
National Express — 0871 7818181

GENERAL

Citizen's Advice Bureau, St Aldates — 01865 247578
Town Hall, St Aldates — 01865 249811
University Offices, Wellington Square — 01865 270001
Cherwell Boathouse, Bardwell Road — 01865 515978
Magdalen Bridge Punts — 01865 202643

EMERGENCY

John Radcliffe Hospital, Headington — 01865 741166
St Aldates Police Station, St Aldates — 0845 8505505

2023 Year Planner

	Sa	Su	M	Tu	W	Th	F	Sa	Su	M	Tu	W	Th	F	Sa	Su	M	Tu
JAN		1	2	3	4	5	6	7	8	9	10	11	12	13	14	15	16	17
FEB					1	2	3	4	5	6	7	8	9	10	11	12	13	14
MAR					1	2	3	4	5	6	7	8	9	10	11	12	13	14
APR	1	2	3	4	5	6	7	8	9	10	11	12	13	14	15	16	17	18
MAY			1	2	3	4	5	6	7	8	9	10	11	12	13	14	15	16
JUN						1	2	3	4	5	6	7	8	9	10	11	12	13
JUL	1	2	3	4	5	6	7	8	9	10	11	12	13	14	15	16	17	18
AUG				1	2	3	4	5	6	7	8	9	10	11	12	13	14	15
SEP							1	2	3	4	5	6	7	8	9	10	11	12
OCT		1	2	3	4	5	6	7	8	9	10	11	12	13	14	15	16	17
NOV					1	2	3	4	5	6	7	8	9	10	11	12	13	14
DEC							1	2	3	4	5	6	7	8	9	10	11	12

6

Denotes provisional bank holiday dates

W	Th	F	Sa	Su	M	Tu	W	Th	F	Sa	Su	M	Tu	W	Th	F	Sa	Su
18	19	20	21	22	23	24	25	26	27	28	29	30	31					
15	16	17	18	19	20	21	22	23	24	25	26	27	28					
15	16	17	18	19	20	21	22	23	24	25	26	27	28	29	30	31		
19	20	21	22	23	24	25	26	27	28	29	30							
17	18	19	20	21	22	23	24	25	26	27	28	29	30	31				
14	15	16	17	18	19	20	21	22	23	24	25	26	27	28	29	30		
19	20	21	22	23	24	25	26	27	28	29	30	31						
16	17	18	19	20	21	22	23	24	25	26	27	28	29	30	31			
13	14	15	16	17	18	19	20	21	22	23	24	25	26	27	28	29	30	
18	19	20	21	22	23	24	25	26	27	28	29	30	31					
15	16	17	18	19	20	21	22	23	24	25	26	27	28	29	30			
13	14	15	16	17	18	19	20	21	22	23	24	25	26	27	28	29	30	31

Denotes provisional bank holiday dates

Calendar 2023

January

Mon		2	9	16	23	30
Tue		3	10	17	24	31
Wed		4	11	18	25	
Thur		5	12	19	26	
Fri		6	13	20	27	
Sat		7	14	21	28	
Sun	1	8	15	22	29	

February

Mon		6	13	20	27
Tue		7	14	21	28
Wed	1	8	15	22	
Thur	2	9	16	23	
Fri	3	10	17	24	
Sat	4	11	18	25	
Sun	5	12	19	26	

March

Mon		6	13	20	27
Tue		7	14	21	28
Wed	1	8	15	22	29
Thur	2	9	16	23	30
Fri	3	10	17	24	31
Sat	4	11	18	25	
Sun	5	12	19	26	

April

Mon		3	10	17	24
Tue		4	11	18	25
Wed		5	12	19	26
Thur		6	13	20	27
Fri		7	14	21	28
Sat	1	8	15	22	29
Sun	2	9	16	23	30

May

Mon	1	8	15	22	29
Tue	2	9	16	23	30
Wed	3	10	17	24	31
Thur	4	11	18	25	
Fri	5	12	19	26	
Sat	6	13	20	27	
Sun	7	14	21	28	

June

Mon		5	12	19	26
Tue		6	13	20	27
Wed		7	14	21	28
Thur	1	8	15	22	29
Fri	2	9	16	23	30
Sat	3	10	17	24	
Sun	4	11	18	25	

July

Mon		3	10	17	24	31
Tue		4	11	18	25	
Wed		5	12	19	26	
Thur		6	13	20	27	
Fri		7	14	21	28	
Sat	1	8	15	22	29	
Sun	2	9	16	23	30	

August

Mon		7	14	21	28
Tue	1	8	15	22	29
Wed	2	9	16	23	30
Thur	3	10	17	24	31
Fri	4	11	18	25	
Sat	5	12	19	26	
Sun	6	13	20	27	

September

Mon		4	11	18	25
Tue		5	12	19	26
Wed		6	13	20	27
Thur		7	14	21	28
Fri	1	8	15	22	29
Sat	2	9	16	23	30
Sun	3	10	17	24	

October

Mon		2	9	16	23	30
Tue		3	10	17	24	31
Wed		4	11	18	25	
Thur		5	12	19	26	
Fri		6	13	20	27	
Sat		7	14	21	28	
Sun	1	8	15	22	29	

November

Mon		6	13	20	27
Tue		7	14	21	28
Wed	1	8	15	22	29
Thur	2	9	16	23	30
Fri	3	10	17	24	
Sat	4	11	18	25	
Sun	5	12	19	26	

December

Mon		4	11	18	25
Tue		5	12	19	26
Wed		6	13	20	27
Thur		7	14	21	28
Fri	1	8	15	22	29
Sat	2	9	16	23	30
Sun	3	10	17	24	31

Denotes provisional bank holiday dates

Calendar 2024

January

Mon	1	8	15	22	29
Tue	2	9	16	23	30
Wed	3	10	17	24	31
Thur	4	11	18	25	
Fri	5	12	19	26	
Sat	6	13	20	27	
Sun	7	14	21	28	

February

Mon		5	12	19	26
Tue		6	13	20	27
Wed		7	14	21	28
Thur	1	8	15	22	29
Fri	2	9	16	23	
Sat	3	10	17	24	
Sun	4	11	18	25	

March

Mon		4	11	18	25
Tue		5	12	19	26
Wed		6	13	20	27
Thur		7	14	21	28
Fri	1	8	15	22	29
Sat	2	9	16	23	30
Sun	3	10	17	24	31

April

Mon	1	8	15	22	29
Tue	2	9	16	23	30
Wed	3	10	17	24	
Thur	4	11	18	25	
Fri	5	12	19	26	
Sat	6	13	20	27	
Sun	7	14	21	28	

May

Mon		6	13	20	27
Tue		7	14	21	28
Wed	1	8	15	22	29
Thur	2	9	16	23	30
Fri	3	10	17	24	31
Sat	4	11	18	25	
Sun	5	12	19	26	

June

Mon		3	10	17	24
Tue		4	11	18	25
Wed		5	12	19	26
Thur		6	13	20	27
Fri		7	14	21	28
Sat	1	8	15	22	29
Sun	2	9	16	23	30

July

Mon	1	8	15	22	29
Tue	2	9	16	23	30
Wed	3	10	17	24	31
Thur	4	11	18	25	
Fri	5	12	19	26	
Sat	6	13	20	27	
Sun	7	14	21	28	

August

Mon		5	12	19	26
Tue		6	13	20	27
Wed		7	14	21	28
Thur	1	8	15	22	29
Fri	2	9	16	23	30
Sat	3	10	17	24	31
Sun	4	11	18	25	

September

Mon		2	9	16	23	30
Tue		3	10	17	24	
Wed		4	11	18	25	
Thur		5	12	19	26	
Fri		6	13	20	27	
Sat		7	14	21	28	
Sun	1	8	15	22	29	

October

Mon		7	14	21	28
Tue	1	8	15	22	29
Wed	2	9	16	23	30
Thur	3	10	17	24	31
Fri	4	11	18	25	
Sat	5	12	19	26	
Sun	6	13	20	27	

November

Mon		4	11	18	25
Tue		5	12	19	26
Wed		6	13	20	27
Thur		7	14	21	28
Fri	1	8	15	22	29
Sat	2	9	16	23	30
Sun	3	10	17	24	

December

Mon		2	9	16	23	30
Tue		3	10	17	24	31
Wed		4	11	18	25	
Thur		5	12	19	26	
Fri		6	13	20	27	
Sat		7	14	21	28	
Sun	1	8	15	22	29	

Denotes provisional bank holiday dates

Birthdays/Anniversaries

January

February

March

April

Birthdays/Anniversaries

May

June

July

August

Birthdays/Anniversaries

September

October

November

December

Week 36
Sunrise/Sunset
06:23/19:42

Monday 5

Tuesday 6

Wednesday 7

Thursday 8

Friday 9

Full Moon ◯

Saturday 10

Sunday 11

12 Monday

Week 37
Sunrise/Sunset
06:34/19:26

13 Tuesday

14 Wednesday

15 Thursday

16 Friday

17 Saturday

Last Quarter ◗

18 Sunday

Week 38
Sunrise/Sunset
06:46/19:10

Monday 19

Tuesday 20

Wednesday 21

Thursday 22

Friday 23
Autumnal Equinox

Saturday 24

New Moon ●

Sunday 25

26 Monday

Week 39
Sunrise/Sunset
06:57/18:54

27 Tuesday

28 Wednesday

29 Thursday

30 Friday

1 Saturday **October**

2 Sunday

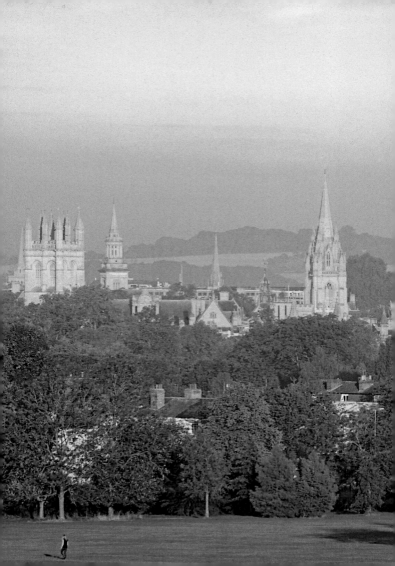

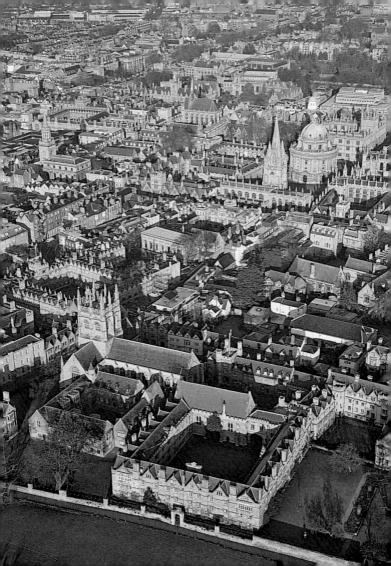

Week 40

Sunrise/Sunset
07:08/18:38

First Quarter 🌓

Monday 3

Tuesday 4

Wednesday 5

Thursday 6

Friday 7

Saturday 8

Full Moon ○ Sunday 9

Oxford from the air

10 Monday

11 Tuesday

12 Wednesday

13 Thursday

14 Friday

15 Saturday

16 Sunday

Week 42

Sunrise/Sunset
07:32/18:07

Last Quarter ◖

Monday 17

Tuesday 18

Wednesday 19

Thursday 20

Friday 21

Saturday 22

Sunday 23

24 Monday

25 Tuesday

New Moon ⬤

26 Wednesday

27 Thursday

28 Friday

29 Saturday

30 Sunday
British Summer Time ends

Isis Lock on the Oxford Canal

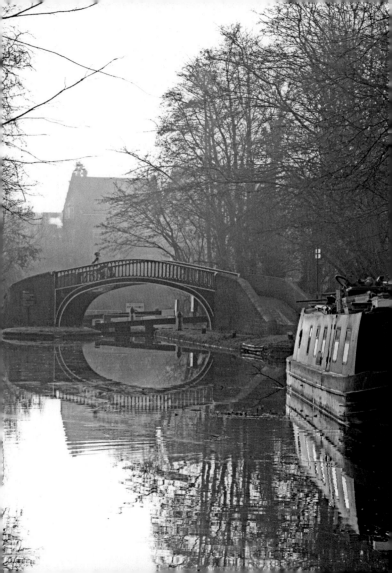

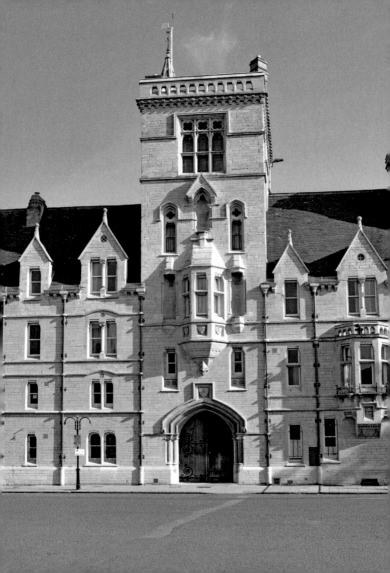

Week 44

Sunrise/Sunset
06:57/16:39

Monday 31

November

First Quarter ◐

Tuesday 1

Wednesday 2

Thursday 3

Friday 4

Saturday 5

Sunday 6

7 Monday

8 Tuesday

Full Moon ◯

9 Wednesday

10 Thursday

11 Friday

12 Saturday

13 Sunday
Remembrance Sunday

Week 46

Sunrise/Sunset
07:22/16:16

Monday 14

Tuesday 15

Last Quarter ◗ Wednesday 16

Thursday 17

Friday 18

Saturday 19

Sunday 20

21 Monday

22 Tuesday

23 Wednesday

New Moon ●

24 Thursday

25 Friday

26 Saturday

27 Sunday

Trinity College Chapel

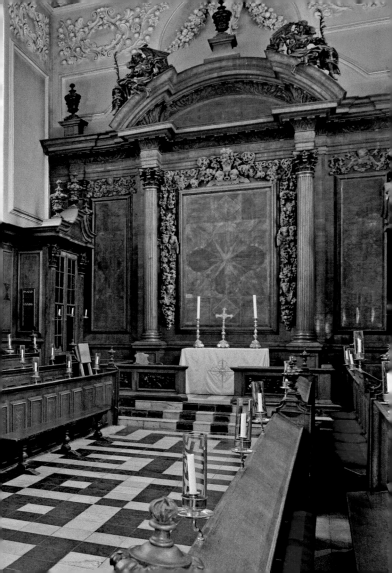

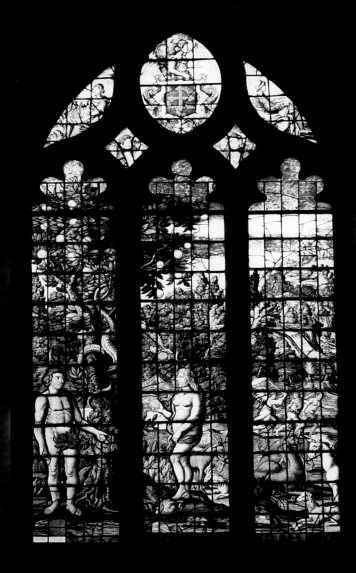

Week 48
Sunrise/Sunset
07:44/16:00

Monday 28

Tuesday 29

First Quarter ◑

Wednesday 30
St Andrew's Day

December

Thursday 1

Friday 2

Saturday 3

Sunday 4

Stained glass in Universtiy College Chapel

5	Monday

6	Tuesday

7	Wednesday

8	Thursday

Full Moon ◯

9	Friday

10	Saturday

11	Sunday

Week 50

Sunrise/Sunset
08:02/15:54

Monday 12

Tuesday 13

Wednesday 14

Thursday 15

Last Quarter ◖ Friday 16

Saturday 17

Sunday 18

19 Monday

20 Tuesday

21 Wednesday
Winter Solstice

22 Thursday

23 Friday

New Moon ●

24 Saturday

25 Sunday
Christmas Day

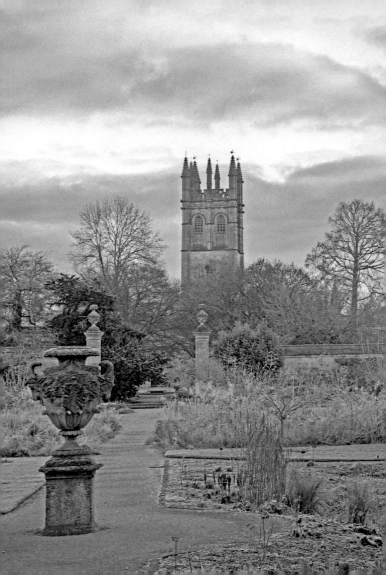

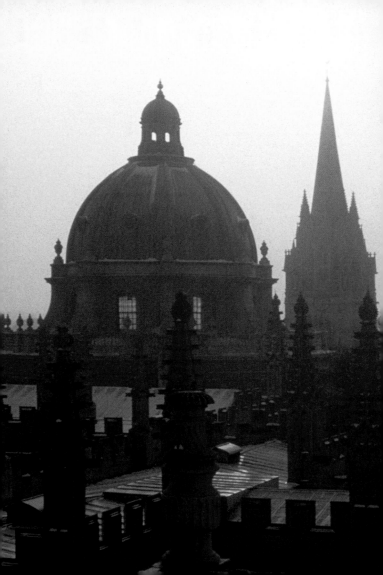

Week 52
Sunrise/Sunset
08:11/15:59

Monday 26
Boxing Day

Tuesday 27
Christmas Day Bank Holiday

Wednesday 28

Thursday 29

First Quarter ◑

Friday 30

Saturday 31

January

Sunday 1
New Year's Day

Radcliffe Camera & St Mary's Church

2	**Monday**	**Week 1**
	New Year's Day Bank Holiday	*Sunrise/Sunset* *08:11/16:06*

3 Tuesday

4 Wednesday

5 Thursday

6 Friday *Full Moon* ◯

7 Saturday

8 Sunday

Week 2

Sunrise/Sunset
08:09/16:14

Monday 9

Tuesday 10

Wednesday 11

Thursday 12

Friday 13

Saturday 14

Last Quarter ◑

Sunday 15

16 Monday

17 Tuesday

18 Wednesday

19 Thursday

20 Friday

21 Saturday

New Moon ●

22 Sunday

Tom Tower, Christ Church

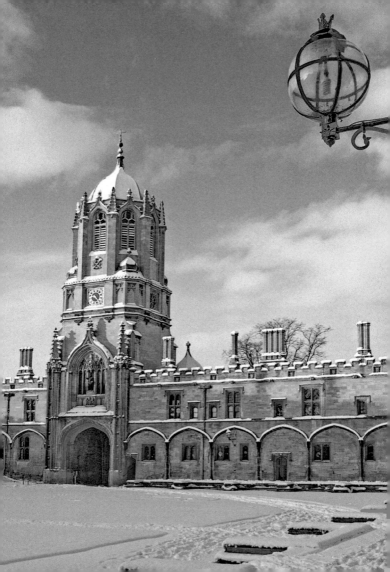

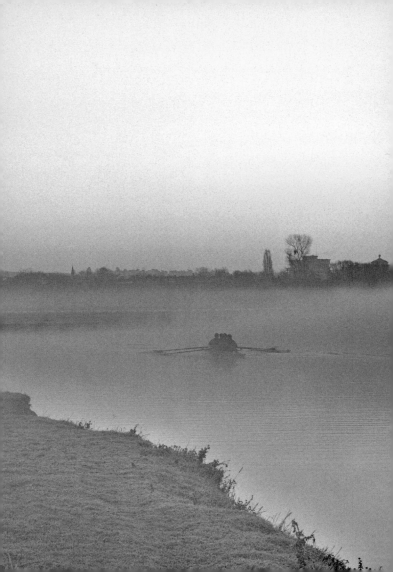

Week 4

Sunrise/Sunset
07:57/16:37

Monday 23

Tuesday 24

Wednesday 25

Thursday 26

Friday 27

First Quarter ◖

Saturday 28

Sunday 29

Early morning rowing on Port Meadow

30 Monday

31 Tuesday

1 Wednesday

February

2 Thursday

3 Friday

4 Saturday

5 Sunday

Full Moon ◯

Week 6
Sunrise/Sunset
07:36/17:02

Monday 6

Tuesday 7

Wednesday 8

Thursday 9

Friday 10

Saturday 11

Sunday 12

eper

13 Monday

14 Tuesday
St Valentine's Day

15 Wednesday

16 Thursday

17 Friday

18 Saturday

19 Sunday

Statue on the Clarendon Building

Week 8

Sunrise/Sunset
07:10/17:28
New Moon ●

Monday 20

Tuesday 21

Wednesday 22
Ash Wednesday

Thursday 23

Friday 24

Saturday 25

Sunday 26

Christ Church

27 Monday

Week 9
Sunrise/Sunset
06:55/17:40
First Quarter ◐

28 Tuesday

1 Wednesday

March

St David's Day

2 Thursday

3 Friday

4 Saturday

5 Sunday

Week 10

Sunrise/Sunset
06:40/17:53

Monday 6

Full Moon ◯

Tuesday 7

Wednesday 8

Thursday 9

Friday 10

Saturday 11

Sunday 12

13 Monday	**Week 11**
	Sunrise/Sunset
	06:24/18:05

14 Tuesday

15 Wednesday *Last Quarter* ◖

16 Thursday

17 Friday
St Patrick's Day

18 Saturday

19 Sunday
Mothering Sunday

Week 12

Sunrise/Sunset
06:08/18:17

Monday 20
Vernal Equinox

New Moon ●

Tuesday 21

Wednesday 22

Thursday 23

Friday 24

Saturday 25

Sunday 26
British Summer Time begins

Hertford College Bridge of Sighs from the Bodleian Quad

27 Monday

28 Tuesday

29 Wednesday

First Quarter ◗

30 Thursday

31 Friday

1 Saturday

April

2 Sunday

Week 14

Sunrise/Sunset
06:35/19:41

Monday 3

Tuesday 4

Wednesday 5

Full Moon ◯

Thursday 6

Friday 7
Good Friday

Saturday 8

Sunday 9
Easter Sunday

10 Monday
Easter Monday

11 Tuesday

12 Wednesday

13 Thursday

Last Quarter ◗

14 Friday

15 Saturday

16 Sunday

Week 16

Sunrise/Sunset
06:05/20:05

Monday 17

Tuesday 18

Wednesday 19

New Moon ●

Thursday 20

Friday 21

Saturday 22

Sunday 23
St George's Day

View over the Bodleian Library Roof

24 Monday

25 Tuesday

26 Wednesday

27 Thursday

First Quarter ◐

28 Friday

29 Saturday

30 Sunday

Week 18　**May**

Sunrise/Sunset
05:36/20:28

Monday　1

May Day Bank Holiday

Tuesday　2

Wednesday　3

Thursday　4

Full Moon ◯

Friday　5

Saturday　6

Sunday　7

8 Monday	**Week 19**
	Sunrise/Sunset
	05:24/20:40

9 Tuesday

10 Wednesday

11 Thursday

12 Friday *Last Quarter* ◑

13 Saturday

14 Sunday

Week 20
Sunrise/Sunset
05:12/20:51

Monday 15

Tuesday 16

Wednesday 17

Thursday 18

New Moon ●

Friday 19

Saturday 20

Sunday 21

22 Monday

23 Tuesday

24 Wednesday

25 Thursday

26 Friday

27 Saturday

First Quarter ◑

28 Sunday

Week 22
Sunrise/Sunset
04:55/21:10

Monday 29
Spring Bank Holiday

Tuesday 30

Wednesday 31

June

Thursday 1

Friday 2

Saturday 3

Full Moon ◯

Sunday 4

5 Monday	**Week 23**
	Sunrise/Sunset
	04:49/21:17

6 Tuesday

7 Wednesday

8 Thursday

9 Friday

10 Saturday *Last Quarter* ◗

11 Sunday

Week 24
Sunrise/Sunset
04:45/21:23

Monday 12

Tuesday 13

Wednesday 14

Thursday 15

Friday 16

Saturday 17

New Moon ●

Sunday 18
Father's Day

Encaenia Procession

19 Monday

20 Tuesday

21 Wednesday
Summer Solstice

22 Thursday

23 Friday

24 Saturday

25 Sunday

Week 26

Sunrise/Sunset
04:47/21:27
First Quarter ◖

Monday 26

Tuesday 27

Wednesday 28

Thursday 29

Friday 30

July

Saturday 1

Sunday 2

3 Monday

4 Tuesday

5 Wednesday

6 Thursday

7 Friday

8 Saturday

9 Sunday

2024 Diary - spiral bound

To order diaries with this layout and new pictures for 2024 please complete the form below, stating design and quantity and return with your **payment to:**

Chris Andrews Publications Ltd
15 Curtis Yard
North Hinksey Lane
Oxford OX2 0LX

Tel: 01865 723404
Fax: 01865 244243
Email: sales@cap-ox.com
Web: www.cap-ox.com

Quantity

Oxford _____

Cotswolds _____

Guernsey - please call

COST INC. CARRIAGE	
UK	£11.25
Europe	£14.40
Rest of World	£16.20

Please write in capitals and include a telephone number or email address

Enclose cheque payable to: **Chris Andrews Publications Ltd** or debit credit card

Card No: _____ / _____ / _____ / _____

Expiry Date: ____/____ Security code: _____ (on reverse)

Name: _____

Address: _____

_____ Postcode: _____

Tel No: _____

Email: _____

The Romance Series: Oxford, Cotswolds

2024 Wall Calendar

To order wall calendars for 2024 please complete the form below, stating design and quantity and return with your **payment to**:

Chris Andrews Publications Ltd
15 Curtis Yard
North Hinksey Lane
Oxford OX2 0LX

Tel: 01865 723404
Fax: 01865 244243
Email: sales@cap-ox.com
Web: www.cap-ox.com

Quantity

Oxford _____

Cotswolds _____

COST INC. CARRIAGE	
UK	£12.50
Europe	£16.00
Rest of World	£18.00

Please write in capitals and include a telephone number or email address

Enclose cheque payable to: **Chris Andrews Publications Ltd**
or debit credit card

Card No: _____ / _____ / _____ / _____

Expiry Date: ____/____ Security code: _____ (on reverse)

Name: _____

Address: _____

_____ Postcode: _____

Tel No: _____

Email: _____

Week 28

Sunrise/Sunset
04:58/21:21

Last Quarter ◗

Monday 10

Tuesday 11

Wednesday 12

Thursday 13

Friday 14

Saturday 15

Sunday 16

17 Monday

<div align="right">

Week 29
Sunrise/Sunset
05:06/21:15
New Moon ●

</div>

18 Tuesday

19 Wednesday

20 Thursday

21 Friday

22 Saturday

23 Sunday

Week 30
Sunrise/Sunset
05:15/21:06

Monday 24

First Quarter ◗

Tuesday 25

Wednesday 26

Thursday 27

Friday 28

Saturday 29

Sunday 30

31 Monday

1 Tuesday

August

Full Moon ◯

2 Wednesday

3 Thursday

4 Friday

5 Saturday

6 Sunday

Spires over the Isis

Week 32

Sunrise/Sunset
05:36/20:44

Monday 7

Tuesday 8

Last Quarter ◗

Wednesday 9

Thursday 10

Friday 11

Saturday 12

Sunday 13

14 Monday

15 Tuesday

16 Wednesday

New Moon ●

17 Thursday

18 Friday

19 Saturday

20 Sunday

Week 34

Sunrise/Sunset
05:58/20:16

Monday 21

Tuesday 22

Wednesday 23

First Quarter ◑

Thursday 24

Friday 25

Saturday 26

Sunday 27

28 Monday
Summer Bank Holiday

Week 35
Sunrise/Sunset
06:10/20:01

29 Tuesday

30 Wednesday

31 Thursday

Full Moon ◯

1 Friday

September

2 Saturday

3 Sunday

The Cloister, Magdalen College

Week 36
Sunrise/Sunset
06:21/19:45

Monday 4

Tuesday 5

Last Quarter ◐ Wednesday 6

Thursday 7

Friday 8

Saturday 9

Sunday 10

11 Monday

12 Tuesday

13 Wednesday

14 Thursday

15 Friday

New Moon ●

16 Saturday

17 Sunday

Week 38

Sunrise/Sunset
06:44/19:13

Monday 18

Tuesday 19

Wednesday 20

Thursday 21

First Quarter ◑

Friday 22

Saturday 23

Autumnal Equinox

Sunday 24

25 Monday Week 39
Sunrise/Sunset
06:55/18:57

26 Tuesday

27 Wednesday

28 Thursday

29 Friday *Full Moon* ◯

30 Saturday

1 Sunday **October**

View of Radcliffe Square from the Exam Schools Quad

Week 40

Sunrise/Sunset
07:05/18:41

Monday 2

Tuesday 3

Wednesday 4

Thursday 5

Last Quarter ◐ Friday 6

Saturday 7

Sunday 8

Worcester College Lake

9 Monday

10 Tuesday

11 Wednesday

12 Thursday

13 Friday

14 Saturday

New Moon ●

15 Sunday

Week 42

Sunrise/Sunset
07:30/18:09

Monday 16

Tuesday 17

Wednesday 18

Thursday 19

Friday 20

Saturday 21

First Quarter ◑

Sunday 22

23 Monday

24 Tuesday

25 Wednesday

26 Thursday

27 Friday

28 Saturday

Full Moon ◯

29 Sunday

British Summer Time ends

Week 44
Sunrise/Sunset
06:55/16:41

Monday 30

Tuesday 31

November

Wednesday 1

Thursday 2

Friday 3

Saturday 4

Last Quarter ◖

Sunday 5

6 Monday

7 Tuesday

8 Wednesday

9 Thursday

10 Friday

11 Saturday

12 Sunday
Remembrance Sunday

Week 46

Sunrise/Sunset
07:19/16:18

New Moon ●

Monday 13

Tuesday 14

Wednesday 15

Thursday 16

Friday 17

Saturday 18

Sunday 19

20 Monday

Week 47
Sunrise/Sunset
07:31/16:08
First Quarter ◗

21 Tuesday

22 Wednesday

23 Thursday

24 Friday

25 Saturday

26 Sunday

Week 48

Sunrise/Sunset
07:43/16:01
Full Moon ◯

Monday 27

Tuesday 28

Wednesday 29

Thursday 30
St Andrew's Day

December

Friday 1

Saturday 2

Sunday 3

View of Tom Tower from the Memorial Gardens, Christ Church

4 Monday

5 Tuesday

Last Quarter ◗

6 Wednesday

7 Thursday

8 Friday

9 Saturday

10 Sunday

Week 50
Sunrise/Sunset
08:01/15:54

Monday 11

New Moon ●

Tuesday 12

Wednesday 13

Thursday 14

Friday 15

Saturday 16

Sunday 17

18 Monday

19 Tuesday

First Quarter 🌓

20 Wednesday

21 Thursday

22 Friday
Winter Solstice

23 Saturday

24 Sunday

Week 52

Sunrise/Sunset
08:11/15:58

Monday 25
Christmas Day

Tuesday 26
Boxing Day

Full Moon ◯

Wednesday 27

Thursday 28

Friday 29

Saturday 30

Sunday 31

1	**Monday** *New Year's Day*	**January**	Week 1

Sunrise/Sunset
08:11/16:04

2 Tuesday

3 Wednesday

4 Thursday *Last Quarter* ◑

5 Friday

6 Saturday

7 Sunday

Week 2

Sunrise/Sunset
08:10/16:13

Monday 8

Tuesday 9

Wednesday 10

New Moon ●

Thursday 11

Friday 12

Saturday 13

Sunday 14

15 Monday

16 Tuesday

17 Wednesday

18 Thursday

First Quarter ◐

19 Friday

20 Saturday

21 Sunday

Week 4
Sunrise/Sunset
07:58/16:34

Monday 22

Tuesday 23

Wednesday 24

Full Moon ◯ Thursday 25

Friday 26

Saturday 27

Sunday 28

29 Monday

Week 5
Sunrise/Sunset
07:49/16:47

30 Tuesday

31 Wednesday

1 Thursday **February**

2 Friday *Last Quarter* ◐

3 Saturday

4 Sunday

Week 6

Sunrise/Sunset
07:38/17:00

Monday　5

Tuesday　6

Wednesday　7

Thursday　8

New Moon ●　　　　　　　　　　　Friday　9

Saturday　10

Sunday　11

2024 Year Planner

	Sa	Su	M	Tu	W	Th	F	Sa	Su	M	Tu	W	Th	F	Sa	Su	M	Tu
JAN			1	2	3	4	5	6	7	8	9	10	11	12	13	14	15	16
FEB						1	2	3	4	5	6	7	8	9	10	11	12	13
MAR							1	2	3	4	5	6	7	8	9	10	11	12
APR			1	2	3	4	5	6	7	8	9	10	11	12	13	14	15	16
MAY					1	2	3	4	5	6	7	8	9	10	11	12	13	14
JUN	1	2	3	4	5	6	7	8	9	10	11	12	13	14	15	16	17	18
JUL			1	2	3	4	5	6	7	8	9	10	11	12	13	14	15	16
AUG						1	2	3	4	5	6	7	8	9	10	11	12	13
SEP		1	2	3	4	5	6	7	8	9	10	11	12	13	14	15	16	17
OCT				1	2	3	4	5	6	7	8	9	10	11	12	13	14	15
NOV							1	2	3	4	5	6	7	8	9	10	11	12
DEC		1	2	3	4	5	6	7	8	9	10	11	12	13	14	15	16	17

Denotes provisional bank holiday dates

2024 Year Planner

W	Th	F	Sa	Su	M	Tu	W	Th	F	Sa	Su	M	Tu	W	Th	F	Sa	Su
17	18	19	20	21	22	23	24	25	26	27	28	29	30	31				
14	15	16	17	18	19	20	21	22	23	24	25	26	27	28	29			
13	14	15	16	17	18	19	20	21	22	23	24	25	26	27	28	29	30	31
17	18	19	20	21	22	23	24	25	26	27	28	29	30					
15	16	17	18	19	20	21	22	23	24	25	26	27	28	29	30	31		
19	20	21	22	23	24	25	26	27	28	29	30							
17	18	19	20	21	22	23	24	25	26	27	28	29	30	31				
14	15	16	17	18	19	20	21	22	23	24	25	26	27	28	29	30	31	
18	19	20	21	22	23	24	25	26	27	28	29	30						
16	17	18	19	20	21	22	23	24	25	26	27	28	29	30	31			
13	14	15	16	17	18	19	20	21	22	23	24	25	26	27	28	29	30	
18	19	20	21	22	23	24	25	26	27	28	29	30	31					

Denotes provisional bank holiday dates

Names & Addresses

Name	Contact Details

Names & Addresses

Name	Contact Details

Names & Addresses

Name	Contact Details

Names & Addresses

Name	Contact Details

Notes

The pictures in this publication are available as enlarged editions or for use in any other way. If you would like further details please contact:

Chris Andrews Publications ltd
15 Curtis Yard
North Hinksey Lane
Oxford
OX2 0LX

Tel: +44 (0)1865 723404
Fax: +44 (0)1865 244243
Email: sales@cap-ox.com
Web: www.cap-ox.com

OTHER PUBLICATIONS

Calendars: Oxford, Cotswolds, Alderney, Guernsey
Diaries: Oxford, Cotswolds, Guernsey
Books: Oxford Scene
Oxford the Colleges & University
Oxford Rapid Guide
Cotswold Scene
Cotswolds Practical Guide
The Cotswolds Souvenir guide
Guernsey, Sark & Herm
Belfast a view of the City
Little Souvenir series (see website for titles)
Oxford Colouring book
Oxford Playing Cards
Mary Peters - Passing the Torch

If you would like to receive our mail order catalogue or join our mailing list please email sales@cap-ox.com or call us on the number above

CHRIS ANDREWS
PUBLICATIONS